D1491264

CLAUDE M

water lilies

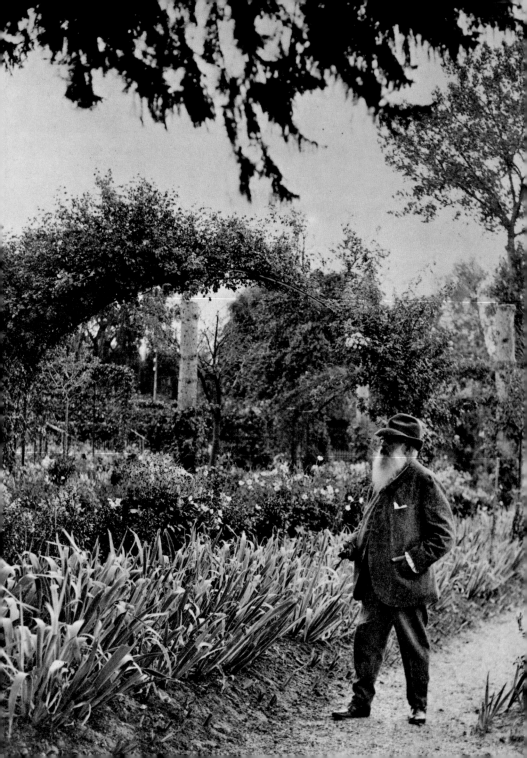

Ann Temkin and Nora Lawrence

CLAUDE MONET
water lilies

The Museum of Modern Art

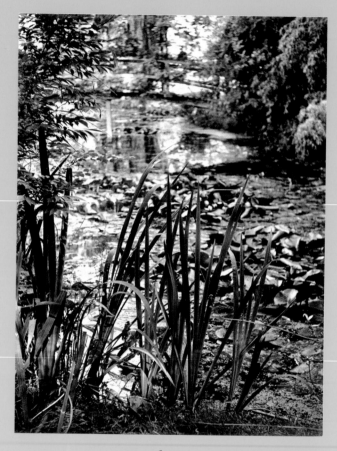

fig. 1
HENRI CARTIER-BRESSON
Untitled (Monet's water lily pond in Giverny), c. 1952
Gelatin-silver print

fig. 2
CLAUDE MONET
Water Lily Pond, 1904
Oil on canvas, 35 3/8 x 36 1/4" (90 x 92 cm)
Musée des Beaux-Arts de Caen, France

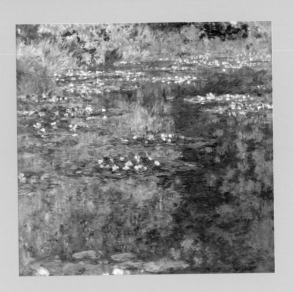

Historical Note

Claude Monet rented a house in Giverny, France, in 1883, purchasing its property in 1890. In 1893 he bought an additional plot of land, across a road and a set of railroad tracks from his house, and there embarked on plans to transform an existing small pond into a magnificent water garden, filled with imported lilies and spanned by a Japanese-style wooden bridge (fig. 1).

This garden setting may well signify "nature," but it was not a purely natural site. Monet lavished an extraordinary amount of time and money on the upkeep and eventual expansion of the pond and the surrounding grounds, ultimately employing six gardeners. Itself a cherished work of art, the garden was the subject of many easel-size paintings Monet made at the turn of the new century and during its first decade. Beginning in 1903 he began to concentrate on works that dispensed with the conventional structure of landscape painting—omitting the horizon line, the sky, and the ground—and focused directly on the surface of the pond and its reflections, sometimes including a hint of the pond's edge to situate the viewer in space (see fig. 2). Compared with later depictions of the pond (see fig. 3), these paintings are quite naturalistic both in color and style. Monet exhibited forty-eight of these Water

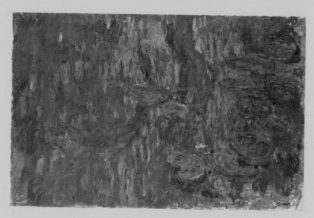

Lilies in a highly successful exhibition at Galerie Durand-Ruel in Paris in May 1909.

As early as 1898 the journalist Maurice Guillemot reported that Monet had plans for "a circular room in which the walls above the baseboard would be covered with [paintings of] water, dotted with these plants to the very horizon."[1] Reporting on Monet's 1909 show in Paris, another critic wrote of the artist's idea for a dining room containing only a table "encircled by these mysteriously seductive reflections."[2] But Monet's path toward fulfilling this vision met with setbacks. The next few years were a time of infrequent artistic activity and significant personal hardship for Monet. Floods in 1910 submerged the water lily pond. His wife, Alice Hoschedé, died in 1911, as did his son Jean, in 1914. In 1912 Monet was diagnosed with cataracts, and for the rest of his life he would struggle with failing eyesight. When World War I began, most of Monet's family members and friends left Giverny, but he stayed, saying that his painting helped distract him from the horrible news of the war.

Indeed, Monet began construction on a vast new studio in 1915. It was utterly utilitarian in design, with a concrete floor and glass ceiling;

Monet lamented that for the sake of his art he had added an eyesore to the property. Thereafter, the artist would work in two stages: in the summer he would paint outdoors on smaller canvases, and in the winter retreat to the studio to make paintings some six-and-a-half feet tall and up to twenty feet wide. Monet worked on several panels at once, going back and forth among them. These works, which he referred to as *grandes décorations*, took the artist to pictorial territory he had not visited in more than fifty years of painting. The compositions zero in on the water's surface so that conventional clues to the artist's—and the viewer's—vantage point are eliminated. The shimmer of light on the water and the intermingling of reflections of the clouds and foliage overhead further blur the distinctions between here and there. The paintings were sufficiently radical that Monet often doubted their worth, and he destroyed some canvases along the way. He made more than forty of these large paintings, reworked over the course of several years.

At the close of the war, Monet decided to donate two panels to France in celebration of the nation's victory. His good friend Georges Clemenceau, who was prime minister of France from 1906 to 1909 and again from 1917 to 1920, persuaded Monet to expand the gift. Eventually, the state received twenty-two panels, forming eight compositions. The gift was contingent upon Monet's right to approve the venue and installation plan for the paintings. After much discussion, Monet and government officials agreed to create a permanent exhibition space at the Orangerie, in the Tuileries garden in Paris. It opened to the public in 1927, the year following Monet's death.

NOTES
1. As quoted in Paul Hayes Tucker, *Claude Monet: Life and Art* (New Haven: Yale University Press, 1995), 198.
2. Ibid., 197.

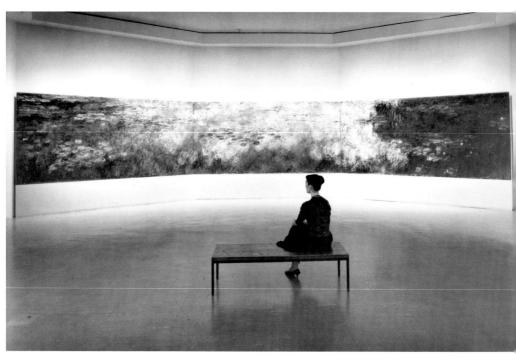

fig. 4
Installation view of *Water Lilies*, 1914–26,
at The Museum of Modern Art, New York, c. 1959

MONET'S
water lilies
at
The Museum of Modern Art

Claude Monet's monumental compositions known as the Water Lilies occupy a unique position among the thousands of paintings in The Museum of Modern Art's collection (see fig. 4). From the moment the first Water Lilies painting arrived in 1955 they have claimed a place apart, most notably in their longtime home in a gallery on the second floor of the Museum's east wing, overlooking the Sculpture Garden (fig. 6). Installed from time to time in the thick of the procession of galleries, or in combination with work by other artists, they have fared less well. What might be the reason for their distinction?

There are many answers to this question. The most obvious is that these paintings were part of the artist's ambition to create a panorama that enveloped the viewer, an environment that in today's parlance would be called an "installation" (see fig. 5). In his day Monet called them *grandes décorations* and painted them in a vast studio built expressly for this purpose on his property in Giverny, France (see fig. 7). He imagined the canvases permanently installed on curving walls, as free of edges and corners as water itself. Monet embarked on this remarkable project in 1914, at seventy-three years of age, and the task of painting the many mural-size panels in this series governed his remaining days. After his death in 1926, twenty-two panels were installed at the Orangerie in Paris, a gift from the artist to the French

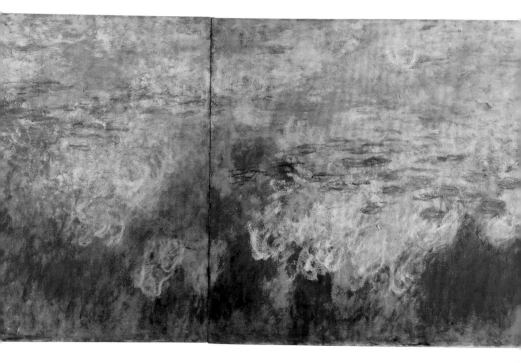

fig. 5
CLAUDE MONET
Water Lilies, 1914–26
Oil on canvas, three panels, each 6' 6 $^3/_4$" x 13' 11 $^1/_4$"
(200 x 424.8 cm); overall 6' 6 $^3/_4$" x 41' 10 $^3/_8$" (200 x 1,276 cm)
The Museum of Modern Art, New York
Mrs. Simon Guggenheim Fund

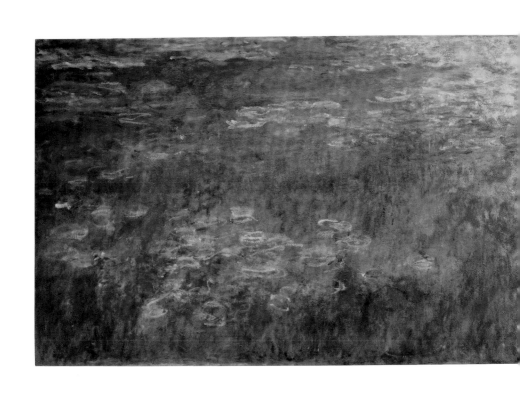

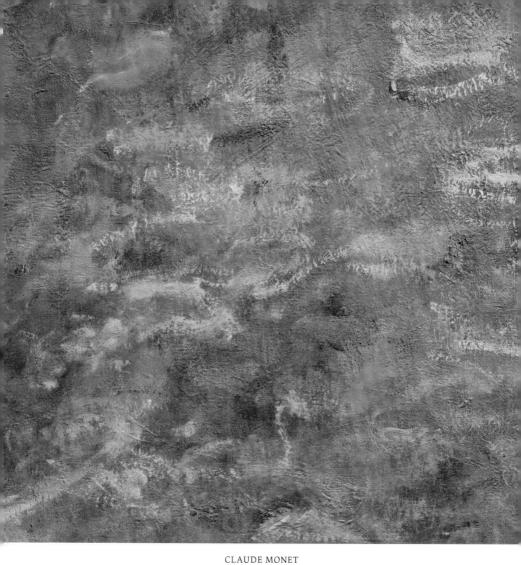

CLAUDE MONET
Water Lilies (details), 1914–26
(see fig. 5, inside flaps)

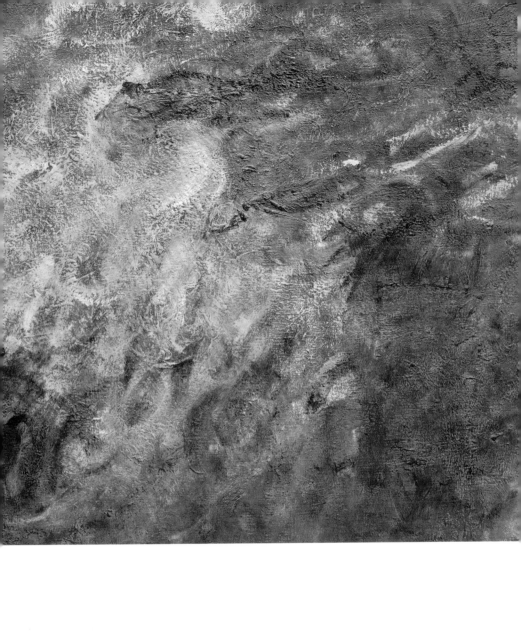

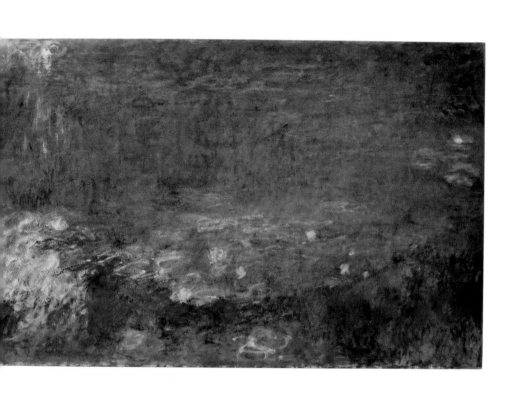

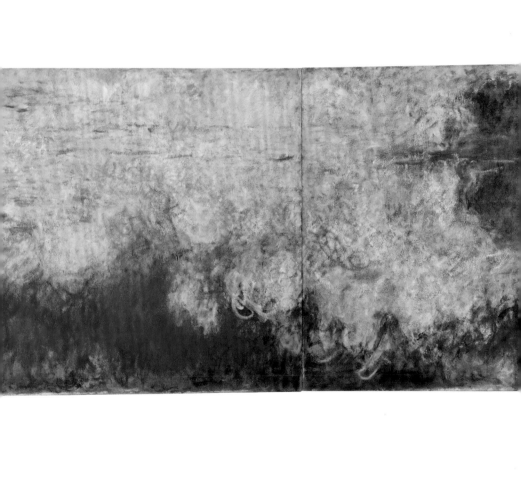

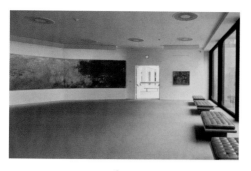

fig. 6
Installation view at The Museum of Modern Art,
New York, c. 1985, showing *Water Lilies*, 1914–26 (left),
and *The Japanese Footbridge*, c. 1920–22

nation (fig. 8). Others, such as those now belonging to The Museum of Modern Art, eventually found homes elsewhere, singly or in small groups. Even when the paintings are encountered one at a time, the artist's environmental vision is apparent in their size, and, more important, in their scale vis-à-vis an individual's perception. Focusing tightly on the surface of the water, Monet succeeded in making paintings that convert the viewer's role from observation to immersion. Thus the Water Lilies' claim on the viewer differs from that of an easel-size painting to be looked at in the company of others. From the outset, the artist envisaged them as all-encompassing.

There are other explanations for the Water Lilies' special status at MoMA, less particular to Monet's paintings than to the structure of the Museum's collections and their display. Itself an artifact of the modernism to which it was dedicated, the Museum generally has presented a trajectory of art devoted to innovation. The Painting and Sculpture galleries long have been designed as a procession of break-throughs highlighting the "invention" of Cubism, of Futurism, of Surrealism; the unspoken analogy might be the course of scientific progress. The modernist idealization of originality—Ezra Pound's pro-verbial "make it new"—resulted in a strong emphasis on beginnings within the span not only of a decade or a century but of an artist's life.[1]

Monet's large Water Lilies, however, are quintessential late works, made in the last decade of the long life of this nineteenth-century artist. Their power is that not of a stroke of inspiration, but of a deeply enduring passion, both for the artist's subject and for his vocation. These paintings stand at far remove from Monet's 1872 painting *Impression, Sunrise*, the work that legend associates with the term

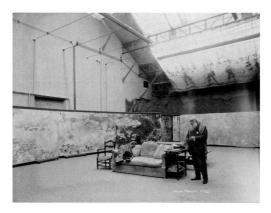

fig. 7
Claude Monet in his studio, 1922

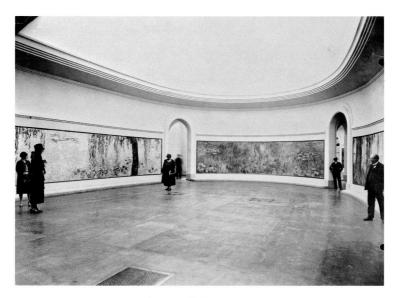

fig. 8
Installation view of
Water Lilies at the Musée de
l'Orangerie, Paris, 1930

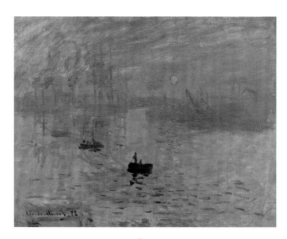

fig. 9
CLAUDE MONET
Impression, Sunrise, 1872
Oil on canvas, 18 $^7/_8$ x 24 $^7/_8$" (48 x 63 cm)
Musée Marmottan-Claude Monet, Paris

"Impressionism," and that declares as its hallmark the spontaneity
of glance and of touch (fig. 9). In contrast, the Water Lilies advertise the
long duration of their making with surfaces that are thick with mul-
tiple layers of paint. The months and years during which the *grandes
décorations* were continually reworked represent the decades of experi-
ence that informed the artist's way of seeing and mark-making.

The late Water Lilies richly demonstrate the often astonishing
gap between the personal chronology of an individual artist and that
of a history of art movements. The conventional charting of the innova-
tions of each new decade that characterizes the history of art is incom-
patible with that of individual lives. A single artist, for example, does
not start out an Abstract Expressionist in the 1950s, become a Pop artist
in the 1960s, and convert to Conceptualism in the 1970s. Generally,
artists maintain the principles and methods they define at the outset
of their careers, modifying and expanding them over the years accord-
ing to a largely internal logic. Already, at the point when Monet began
his *grandes décorations*, Pablo Picasso and Georges Braque had devised
the language of Cubism and Marcel Duchamp had begun a corpus of
"readymade" sculptures by setting a bicycle wheel atop a kitchen stool.

Before the Water Lilies were finished, Piet Mondrian had conceived Neo-Plasticism and Kazimir Malevich had painted *White on White*. Giverny was but an hour from Paris, but as a gentleman in his late seventies and early eighties Monet was content to work in a way coolly oblivious to the ongoing march of modern art.

•••

During the first twenty years of The Museum of Modern Art's history, the Water Lilies did not figure in founding director Alfred H. Barr, Jr.'s thinking for the Museum. Nor did Monet, or still more generally, the Impressionists. The Museum's opening exhibition in November 1929 presented the work of Paul Cézanne, Georges Seurat, Vincent van Gogh, and Paul Gauguin. The names of these four artists would also be arrayed at the top of Barr's chart of "The Development of Abstract Art" that accompanied his 1936 exhibition *Cubism and Abstract Art*. But during the 1950s, exceptionally, Barr would make retroactive room for Claude Monet, and, specifically, for the artist's last paintings. What was to happen provides an extraordinary example of how the appearance of new art can bring to the surface older art that has been previously dismissed or ignored.

In this case, it was the advent of large-scale painting by the Abstract Expressionists that excited Barr's interest in Monet's work at Giverny during the 1910s and 1920s. In the late 1940s, in the wake of World War II, the artists who would come to be known as the New York School developed an approach to painting radically distinct from that of their immediate predecessors in either Europe or the United States. Work that its makers claimed to be fatherless—in Emersonian fashion, a self-reliant American painting—made room for the entrance of a putative precedent. Monet's Water Lilies, as free of polemic as the Americans' work was a clarion call, would come to take on a prominent role. For countless commentators, and completely in spite of themselves, these

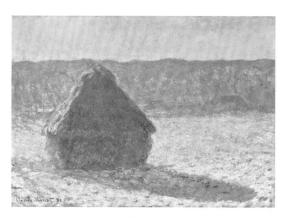

fig. 10
CLAUDE MONET
Grainstack (Snow Effect), 1891
Oil on canvas, 25 3/4 x 36 3/8" (65.4 x 92.4 cm)
Museum of Fine Arts, Boston
Gift of Miss Aimée and Miss Rosamond Lamb
in memory of Mr. and Mrs. Horatio Appleton Lamb

works of an elderly man were transformed into fresh young things. Such was the alchemy of art critics and historians who could turn something that was an ending—Impressionism half a century after its baptism—into a beginning, a forecast of mid-century American painting.[2]

When the Water Lilies first caught Barr's attention, Monet's late works enjoyed none of the glory that they do today. Despite their now-beloved status and jaw-dropping market values, these paintings were the victims of gross neglect for two decades following Monet's death. This situation represented a dramatic reversal in fortune for the great Impressionist. While Monet was working from Giverny in the 1890s, his wealth and popularity attained new heights. His works painted and exhibited in series—such as Grainstacks (see fig. 10), Poplars, or Rouen Cathedral—all sold rapidly. The apparent repetitiveness of the serial paintings, rather than diminishing their perceived worth to collectors, increased the fervor to own one (or more). Monet's exhibition of easel-size Water Lilies canvases at Galerie Durand-Ruel in Paris in 1909 was no exception—it attracted crowds, enticed eager buyers, and won the artist new accolades.

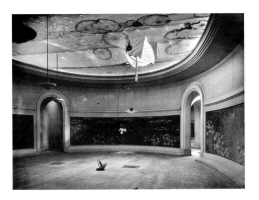

But when Monet devoted himself to following where these paintings led, he outpaced the tastes of his audience. The late paintings, which were largely a studio secret, struck viewers who finally saw them as confusing and messy. The artist's failing eyesight was blamed for illegible composition and an unruly palette.

Soon after the *grandes décorations* were installed in the Orangerie, they were met with indifference. Much to the dismay of Monet's heirs, and despite their protests, over the years the paintings were left to endure in rooms supplied with little light or heat. Water leaked through the dirty skylight of the exhibition space and onto the face of the panels; during World War II bits of shrapnel from the Allied bombings lodged themselves in the canvases (fig. 11). Since Monet had stipulated that the panels never be moved, on at least one occasion another exhibition was hung directly in front of his work.[3] The American artist Jack Youngerman, a visitor to the Orangerie after the war, recalls that the security guards—generally the only people in the rooms besides himself—were disabled veterans of the First World War, their evident trauma exacerbating the gloom he found in the atmosphere.[4]

The situation changed following the end of World War II. In 1952 handsome renovations to the Orangerie were completed, and the Surrealist artist André Masson pronounced the galleries "the Sistine Chapel of Impressionism."[5] The artist's son, Michel Monet, in the meantime began to receive inquiries about the related works, which long had languished in the studio at Giverny. In 1949 he lent five large paintings to an Impressionism exhibition at the Basel Kunsthalle, and another group of five was shipped to the Kunsthaus Zurich in 1952 for inclusion in a Monet retrospective exhibition. In the foreword to the exhibition

catalogue, museum director René Wehrli lauded the underappreciated Water Lilies as precursors of abstract art.[6] Zurich acquired three paintings, and a number of private collectors also made purchases. The first American to do so was the automotive heir and adventurous art collector Walter P. Chrysler, Jr., who bought a large panel in 1950.

The Museum of Modern Art's participation in this wave of purchases was preceded by the acquisition of an earlier Monet: in 1951 Barr accepted as a promised gift from the collection of William B. Jaffe and Evelyn A. J. Hall the painting *Poplars at Giverny, Sunrise*, 1888 (fig. 12). The artist Barnett Newman, an admirer of the Impressionists, noted the acquisition with interest and wrote to Museum President William Burden to ask if this meant the Museum no longer believed that the "modern" began only with Post-Impressionism. He regretted that the Museum had not announced *Poplars* as being the first painting by Monet or any Impressionist to enter the collection: "Why the silence? Is the institution that has dedicated itself for a quarter of a century to the false art history that modern art began with Cézanne afraid now to admit that it is changing its position?"[7] Barr did not view the acquisition as a shift in policy. His letter of thanks to the donor emphasized that the painting nicely complements the Museum's "Post-Impressionist" works and was especially apt "because of the interest in Monet's later work among the younger artists today."[8]

But it was even later Monet—twentieth-century Monet—that was the real object of desire for Barr. At the April 1955 meeting of the Committee on the Museum Collections, Barr reported that Walter Chrysler had informed him that several of Monet's late paintings might still be available for sale at Giverny. It was agreed that James Thrall Soby, chairman of the committee, and Dorothy Miller, curator of museum collections—both in Paris at the time—would visit the studio to choose a work for the Museum.

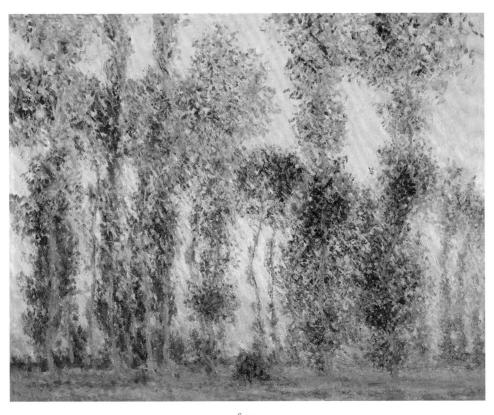

fig. 12
CLAUDE MONET
Poplars at Giverny, Sunrise, 1888
Oil on canvas, 29 ¹/₈ x 36 ¹/₂" (74 x 92.7 cm)
The Museum of Modern Art, New York
The William B. Jaffe and Evelyn A. J. Hall Collection

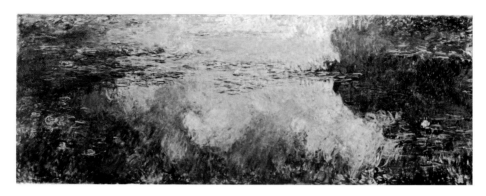

fig. 13
CLAUDE MONET
Water Lilies, 1914–26
Oil on canvas, 6' 6 ³/₄" x 18' 5 ¹/₂" (200 x 562.6 cm)
Formerly The Museum of Modern Art, New York
Mrs. Simon Guggenheim Fund

The paintings' extraordinary size was an immediate issue in the selection process. While in principle Barr was enticed by the size of the Water Lilies paintings, as the director of a collection that was then housed in an already overcrowded building in midtown Manhattan, he was also realistic. Writing that he did not "want to limit whatever you and Dorothy may decide," Barr admitted to Soby, "You know our space problem as well as I do. Anything over 20 feet would be impractical in our current galleries and perhaps out of scale in relation to other things in the Collection but I certainly agree with you that a considerable size may be highly desirable, though possibly 8 or 10 feet would do."[9] A few days later Barr received a telegram from Soby, alerting him that the painting Soby and Miller favored was substantially larger: "BEST MONET 2 BY 5 ¹/₂ METERS PRICE FOUR MILLION FRANCS DOROTHY AND I RECOMMEND CABLE YOUR DECISION REGARDS=SOBY."[10] The next day, Barr wired his approval for the eighteen-and-a-half-foot-wide canvas (fig. 13). "BUY MONET IF YOU DOROTHY REALLY LIKE."[11]

The issue of size was very much on Barr's mind precisely because of the demands that contemporary New York paintings were making on him. What made the Monets problematic also made them relevant. While the Monet would be the widest painting the Museum had

acquired in its twenty-six year history, contemporary abstract paintings made at this scale were much in evidence at Fifty-seventh Street galleries such as Betty Parsons and Sidney Janis. Nevertheless, Barr had only ventured as far as acquiring Jackson Pollock's eight-and-a-half-foot-wide *Number 1, 1948*, and *No. 10*, a seven-and-a-half-foot-tall Mark Rothko of 1950. Works equal in width to the Water Lilies painting, Pollock's *One: Number 31, 1950* and Barnett Newman's *Vir Heroicus Sublimis*, 1950–51 (figs. 14 and 15), would not be acquired until 1968 and 1969, respectively. In 1955 the few large-scale paintings in the Museum's collection justified their magnitude within a tradition of populist mural painting. Picasso's famous protest painting, *Guernica*, 1937 (fig. 16), an imposing twenty-five feet wide, had been on extended loan to the Museum since 1939. Like other large-scale political art in the collection, such as José Clemente Orozco's eighteen-foot-wide fresco *Dive Bomber and Tank*, 1940, *Guernica*'s narrative content set it apart from contemporary abstraction.

The inevitable need to create space in the galleries for a new type of painting was manifest, if not in the collection, in the Museum's temporary exhibitions, which showcased large-scale abstraction sooner than the acquisitions program did so. Dorothy Miller's 1952 exhibition *15 Americans* featured large-scale works by Abstract Expressionist artists Bradley Walker Tomlin, Clyfford Still, Rothko, and Pollock (including his seventeen-foot-wide *Autumn Rhythm: Number 30, 1950*; see fig. 17). Art critic Henry McBride, who wrote about the exhibition for *Art News*, told Miller of his surprise at being confronted by "acres of canvas with so little on them."[12]

It is this environment that conditioned Barr's acceptance of the Water Lilies painting selected by Soby and Miller, a work that also could be perceived, mistakenly, as having "so little" on it. As Barr explained in a letter to Michel Monet, and as he would repeat in several published

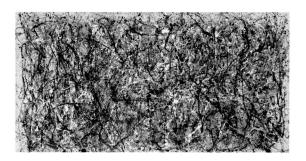

fig. 14
JACKSON POLLOCK
One: Number 31, 1950, 1950
Oil and enamel paint on unprimed canvas,
8' 10" x 17' 5 5/8" (269.5 x 530.8 cm)
The Museum of Modern Art, New York
Sidney and Harriet Janis
Collection Fund (by exchange)

fig. 15
BARNETT NEWMAN
Vir Heroicus Sublimis, 1950–51
Oil on canvas, 7' 11 3/8" x 17' 9 1/4" (242.2 x 541.7 cm)
The Museum of Modern Art, New York
Gift of Mr. and Mrs. Ben Heller

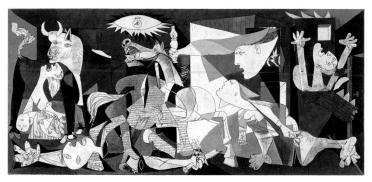

fig. 16
PABLO PICASSO
Guernica, 1937
Oil on canvas, 11' 5 1/2" x 25' 5 11/16" (349.3 x 776.6 cm)
Museo Nacional Centro de Arte Reina Sofía, Madrid

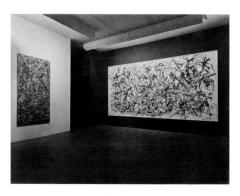

statements to follow, "Interest in your father's work has been considerably revived in this country by our younger artists who are much influenced particularly by his late work."[13] While we do not know exactly what Barr had in mind, it is certain that he was linking late Monet not just to big paintings, but to the phenomenon of abstraction, which had become the dominant approach in American art. The precedent of Cézanne worked well for the subsequent development of Picasso's and Braque's Cubism, Mondrian's Neo-Plasticism, and the sort of geometric abstraction derived from them. But the all-over compositions of a Rothko or a Pollock needed to come from elsewhere, a place that seemed as indifferent to organized structure as the new painting did. Newman's fierce objection to a sole focus on Cézanne as a father figure for his generation was a plea for recognition that the new abstraction came from sources beyond those charted in *Cubism and Abstract Art*.

This was not the first time that Monet had been enlisted in the service of abstraction. In his memoirs Vasily Kandinsky, one of several pioneering voices in abstract art during the years just prior to World War I, credits his encounter with a painting by Monet—on exhibition in Moscow in 1895—with his first awareness that art need not directly represent the visual world:

> Suddenly, for the first time, I saw a picture. That it was a haystack, the catalogue informed me. I didn't recognize it. I found this nonrecognition painful, and thought that the painter had no right to paint so indistinctly. I had a dull feeling that the object was lacking in this picture. . . . It was all unclear to

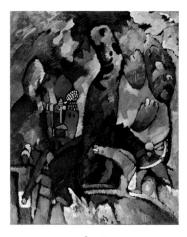

fig. 18
VASILY KANDINSKY
Picture with an Archer, 1909
Oil on canvas, 68 7/8 x 57 3/8" (175 x 144.6 cm)
The Museum of Modern Art, New York
Gift and bequest of Louise Reinhardt Smith

me, and I was not able to draw the simple conclusions from this experience. What was, however, quite clear to me was the unsuspected power of the palette, previously concealed from me, which exceeded all my dreams. Painting took on a fairy-tale power and splendor. And, albeit unconsciously, objects were discredited as an essential element within the picture.[14]

Kandinsky's recollection paid tribute to Monet's inspiration in providing an independent role for the emotional impact of color, quite apart from any connection to what it denoted. Kandinsky's own belief in the spiritual power of color, and the expressive gesture in his painting (see fig. 18), resonated strongly with mid-century art. Barr's written statements in fact often did link Kandinsky to current painting. But in a museum, and a culture at large, oriented more to France than to Germany, the French tradition as represented by Monet was the primary focus of attention.

Monet's Water Lilies painting came to the Museum and was accepted for the collection in June 1955. Like many of the panels in the Orangerie, it was a composition whose center was dominated by bright areas describing the reflections of clouds overhead, intermingling with a horizontal procession of water lilies across the water's surface. It was first displayed at the end of the year as a highlight of the exhibition *Recent Acquisitions (Painting and Sculpture)*. The Museum's press release for the event mentioned in its first sentence "the first showing in this country of one of Monet's famous large water lily paintings."[15] While the exhibition presented nearly fifty newly acquired works of art, Monet's canvas was honored with a dramatic installation

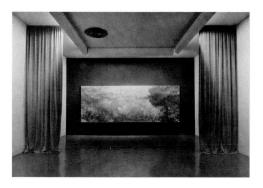

at the end of a cul-de-sac. An exhibition photograph shows that it was theatrically framed by a set of floor-to-ceiling drapes and illuminated against a dark wall (fig. 19). The solitary setting was in keeping with the desires of Michel Monet, who had written to art historian John Rewald, "The painting is indeed beautiful; I hope that it will be well-presented, isolated."[16]

Of the new acquisitions on view, the *New York Times* singled out the Monet as "the biggest surprise, and the greatest triumph for the museum," noting that the painting "shimmers like an impressionist's vision of paradise."[17] A. L. Chanin, writing for *The Nation*, selected the Monet as "the major addition to the collection" and pronounced it "paradoxically . . . at once the most old-fashioned, the least fashionable, and the most daring of the acquisitions."[18] Some two months after the Water Lilies painting first went on display, Barr wrote to Honorary Trustee Mrs. Simon Guggenheim, whose funds enabled the purchase of the composition: "I am a little surprised, but very pleased to know that the Monet has been one of the most generally and enthusiastically admired paintings we have acquired in many years."[19]

This excitement soon translated into additional purchases. When Barr traveled to Paris in June 1956, he visited the exhibition *Les Grandes Evasions poétiques de Claude Monet* at the gallery of Katia Granoff, the dealer who had first brought Walter Chrysler to Giverny in 1950.[20] Barr returned from Paris having reserved not only another Water Lilies canvas for the Museum's consideration, but several others for Museum Trustees and donors, among them a Water Lilies painting now in the collection of the Metropolitan Museum of Art (fig. 20). For the Museum he chose a six-foot, nearly square-format painting, with sweeping tall

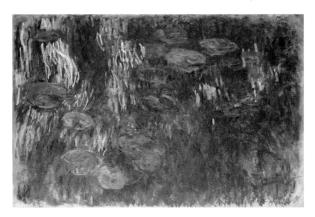

fig. 20
CLAUDE MONET
Water Lilies, 1914–26
Oil on canvas, 51 ¹/₄" x 6' 7" (130.2 x 200.7 cm)
The Metropolitan Museum of Art
Gift of Louise Reinhardt Smith, 1983

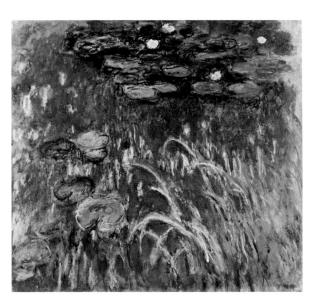

fig. 21
CLAUDE MONET
Water Lilies, 1914–26
Oil on canvas, 71" x 6' 7" (180.3 x 200.7 cm)
Formerly The Museum of Modern Art, New York
Grace Rainey Rogers Fund

grass painted in brisk strokes toward the bottom and a concentrated area of lily pads and flowers above (fig. 21).

Also that summer Barr reserved *The Japanese Footbridge* at M. Knoedler and Co. in New York (fig. 22). This painting depicts the arching wooden bridge that Monet had built at the northern end of the pond as a place to stand and observe the lily blossoms below. Monet's first series of paintings of the pond in the late 1890s had focused on the footbridge; this painting was among the last of this subject, made in 1920 to 1922. That group featured a fiery palette—maroons, rusts, and oranges—unique within Monet's work, as well as agitated passages of paint ranging from staccato jabs to dense swirls and long skeins of color. Both *The Japanese Footbridge* and the Museum's second *Water Lilies* painting were acquired in 1956, and were described as "supplementing" the large panel purchased the year prior.[21]

The appreciation for Monet noted in Barr's letter to Mrs. Guggenheim was part of a larger phenomenon in which the Museum played a central but by no means isolated role. A veritable who's who of art writers addressed the topic of late Monet during the mid-1950s, in mass media as well as in academic publications. In July 1955 *Vogue*'s art director, the artist Alexander Liberman, gave the magazine's readers a photographic tour of the studio in Giverny.[22] Leo Steinberg's February 1956 "Month in Review" column for *Arts* praised (and reproduced) the Museum's acquisition, describing how "it is wonderful to look at for an hour or so at a time," and detailing the possible revelations when one does.[23] That October in *Art News*, Thomas B. Hess glowingly reviewed an exhibition of Monet's late work at Knoedler, admitting that it overcame a critic's innate skepticism toward anything so fashionable.[24]

Clement Greenberg tackled "The Later Monet" in *Art News Annual* in 1957, claiming, "Today those huge close-ups which are the last *Water Lilies* say—to and with the radical Abstract Expressionists—that a lot

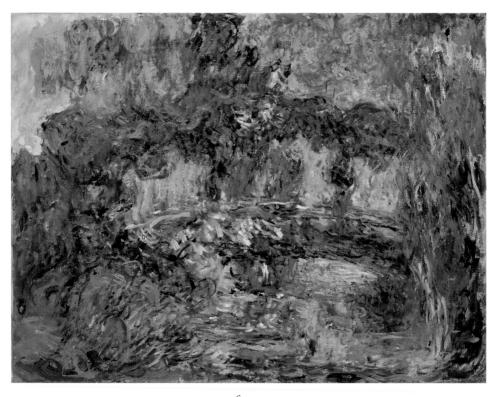

fig. 22
CLAUDE MONET
The Japanese Footbridge, c. 1920–22
Oil on canvas, 35 1/4 x 45 7/8" (89.5 x 116.3 cm)
The Museum of Modern Art, New York
Grace Rainey Rogers Fund

of physical space is needed to develop adequately a strong pictorial idea that does not involve an illusion of deep space."[25] Taking an approach more emotional than formalist in an article entitled "The Big Canvas" in *Art International* in 1958, E. C. Goossen cited Monet's "greatness of spirit, which could only be expressed through greatness of size."[26]

David Sylvester, a young critic in London, reviewed a Monet retrospective at the Tate Gallery for the *New York Times* in October 1957. He called the artist "the art world's most newly resurrected deity, the painter whose standing has risen more than that of any other as a result of post-war movements in taste. . . . Monet has become so eminently respectable that he has almost taken over from Cézanne as modern art's father-figure."[27]

•••

Of the three paintings by Monet to arrive at the Museum in 1955 and 1956, only *The Japanese Footbridge* is part of the collection today. While still newcomers to the Museum, the two Water Lilies panels were to suffer the sort of fate that haunts the dreams of museum directors and curators. On April 15, 1958, a fire broke out in The Museum of Modern Art. It started inside a work zone on the Museum's second floor, where a contract crew was repairing the Museum's air-conditioning system. The *New York Times* reported that a painter's drop cloth had caught fire, perhaps because "workmen had been smoking near piles of sawdust."[28] When the fire reached several open cans of wall paint, the paint apparently ignited and fed the growing blaze. An electrician was killed and at least twenty-five other people were treated for injuries. While approximately 550 paintings were exposed to smoke or water, nearly all of the 2,000 paintings in the Museum were saved.

Two exceptions were the large Water Lilies panel acquired in 1955 and the smaller one that Barr had added in 1956. Like the other

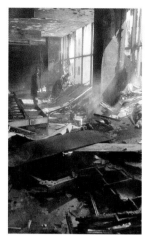

fig. 23
Photograph from *Life* magazine,
April 28, 1958. Original caption:
"After fire, the remains of
Monet's 'Water Lilies' lie
submerged beneath debris of
walls and glass."

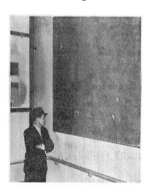

fig. 24
Photograph from the *New York
Herald Tribune*, April 16, 1958.
Original caption: "Examining
Damage—Monroe Wheeler …
of the Museum of Modern Art,
looking at the fire-damaged
painting by Claude Monet
entitled 'Water Lilies,' after
the fire yesterday."

damaged or lost paintings, the large scale of these works
had made it impractical to move them to other parts of the
Museum, as had been done with all the other works on the
second floor. The large Water Lilies panel was left installed
on a wall built in front of the Museum's row of windows
overlooking Fifty-third Street, with a makeshift hard-
board box built around it. After the fire, Museum officials
returned to find the painting buried under a pile of debris
on the ground; firefighters had unknowingly destroyed
it while breaking through the windows into the building
(see fig. 23). The smaller Water Lilies painting, on the other
hand, had succumbed to flames that reached its location in
the stairwell between the second and third floors (see fig. 24).
Pollock's *Number 1, 1948*, installed above it on the third
floor landing, was damaged but successfully conserved.

The rapid response of the New York City Fire
Department saved the collection from far greater destruc-
tion. Barr and his team, in turn, performed heroic work in
guiding both paintings and Museum occupants to safety.
Museum employees were photographed—men in suits
and ties, women in pencil skirts and heels—passing paint-
ings hand over hand in order to get them off the premises,
sometimes working at cross-purposes to the firefighters,
who were trying to evacuate everyone. A "Talk of the Town"
piece in the *New Yorker*, written by a staffer who happened
to be lunching in the Sculpture Garden when the fire began,
marveled at the incongruity of the Museum officials' sudden
new roles: "As we approached the front door, we came on a
fireman who looked like Nelson Rockefeller [the Museum's
chairman], and sure enough it *was* Nelson Rockefeller."[29]

The public was riveted by the dramatic story of the fire, and outpourings of sympathy filled the Museum's mailroom during the spring and summer of 1958. Many of the Museum's Trustees and patrons provided generous funds for reconstruction, and many smaller donations arrived unsolicited. A host of artists, collectors, scholars, and laypersons from New York and around the world expressed their condolences regarding the fire, and many specifically mentioned their sadness at the loss of the large Water Lilies painting (the Museum did not declare the smaller Monet a total loss until late in 1961).[30] Typical in its passion was a letter from a young Dan Flavin, who within a decade would secure his place as one of the leading artists of the Minimalist generation. He wrote, "I will so miss the large picture but any portion of it which can be saved will be enough for me. My heart still aches over the loss."[31] Many other writers, with more than a touch of the macabre, asked if they might receive fragments of the ruined Monet painting as keepsakes.

Within the Museum, the sense of horror surrounding the loss of the two Monets rapidly transformed into a commitment to replace them. Curator Dorothy Miller was in Switzerland at the time of the fire, and Barr had immediately cabled to apprise her of the extent of the damage.[32] Within ten days, he was writing her again—although she was now on vacation—to ask for help in finding another Monet. Miller telephoned Michel Monet at Giverny, whose wife informed her that the studio was now empty—all the paintings having been sold to Katia Granoff in Paris. Before long Miller was in Paris, and she and Granoff went to the studio of the painter René Demeurisse, where Granoff was storing four large Monet paintings, one a single panel (fig. 25) and the others a triptych (fig. 5). Barr knew the works from a previous trip, but followed up on Miller's visit in June and confirmed the desire to have both the triptych and the single panel come to New York for the Committee on the Museum Collections' consideration. As a buyer, the Museum now

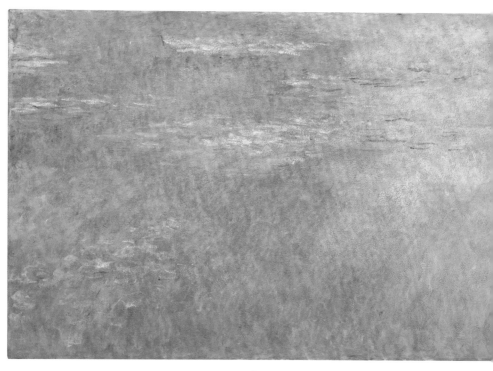

fig. 25
CLAUDE MONET
Water Lilies, 1914–26
Oil on canvas, 6' 6 1/2" x 19' 7 1/2" (199.5 x 599 cm)
The Museum of Modern Art, New York
Mrs. Simon Guggenheim Fund

would suffer the effects of the revolution in taste it had helped spur. A rapid succession of sales to private collectors as well as museum professionals had created a situation of acute scarcity and escalated prices. Whereas Michel Monet had charged the Museum four million francs (then $11,500) for the large painting bought in 1955, just three years later the triptych cost the equivalent of $150,000 and the single panel $83,000.[33]

Barr presented the canvases to the Committee in December 1958. Members encountered, in the triptych, an expanse of painting nearly forty-two feet wide. Clouds painted in pink, violet, and shades of cream fill its center panel (see fig. 26). They are punctuated by small explosions of blossoms on the surface of the water, itself an almost Caribbean turquoise. In the two side panels the palette shifts to a darker key of deep blues, greens, and purples denoting the shaded water, scribbles of green lily pads, and spots of flora.

The single panel, almost twenty feet wide, features a lighter palette and a more diffuse composition. As always, there is no indication of the horizon or pond's edge, but here the viewer is treated to an exceptionally harmonious expanse of painterly reverie. Softly flowing passages of cloud reflections, overhanging foliage, lily pads, and water share the space without dramatic incident. The thickly scumbled surface unifying the whole covers countless layers of magnificent painting now invisible to view.

Barr reported later to Mrs. Simon Guggenheim, who had been unable to attend the meeting:

> The Committee looked at the two compositions for a long
> time, not so much because of doubt as to which we should get,

fig. 26
CLAUDE MONET
Water Lilies (detail), 1914–26
(see fig. 5)

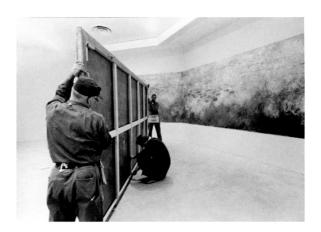

fig. 27
Installing *Water Lilies*, 1914–26, at
The Museum of Modern Art, New York, c. 1959

but because they hold the eye with such fascination. All agreed
that in spite of the additional cost and the problem of space,
we should acquire the triptych. At the same time, all agreed
that if possible, a donor should be found for the twenty-foot
canvas so that ultimately both compositions could be shown
in one room, the triptych at one end, the single panel at the
other. This is a wonderful dream which just possibly might
come true. . . . I think I have rarely seen the Committee in a
more excited state. They were deeply impressed, indeed I could
fairly say spellbound.[34]

Ultimately, Mrs. Guggenheim provided the funds for both the triptych
and the single panel.

Both new purchases required extensive conservation work
before being put on display—the triptych at the end of 1959, and the
single panel a year later (see fig. 27). The twenty-five years of neglect in
the studio, combined with the rigors of subsequent travel, had taken a
heavy toll. In the course of the process conservators removed the origi-
nal warped stretchers from the paintings so that they could attach more
structurally sound supports. Miller, unwilling to throw away what she

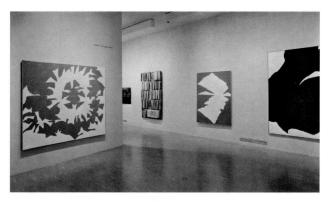

fig. 28
Installation view of *16 Americans* at The Museum of Modern Art,
New York, 1959–60, showing Jack Youngerman's *Aztec III*, 1959 (left);
Palmyra, 1959 (center); and *Big Black*, 1959 (right), with
works by Robert Mallary in background

appreciated as marvelous artifacts, offered the triptych's three original
stretchers to the artists Ellsworth Kelly, Jack Youngerman, and Fred
Mitchell. All three artists made large-scale paintings, and she felt they
would be able to make good use of them.[35] She probably realized that
Kelly and Youngerman, both of whom had shown in her *16 Americans*
exhibition in 1959 (see fig. 28), had spent time in Paris in the early 1950s
and even had visited Giverny.

Indeed, a generation of artists slightly younger than the
Abstract Expressionists could be said to offer closer comparisons to
Monet than those artists who provoked the initial renewed attention
to his work. The actual resemblance between Monet's paintings and
those of such figures as Newman, Still, and Pollock was limited. While
the all-over composition and of course the fact of their size made the
comparison somewhat relevant, Monet's frame of reference was the
mural decoration of nineteenth-century architectural interiors rather
than autonomous paintings. Moreover, Monet's manner of painting
had virtually nothing in common with that of these painters—just as
their own manners of painting had little in common with each other.
Monet's *Water Lilies* paintings were fundamentally based on the obser-
vation of nature. The artist worked outdoors to make the paintings

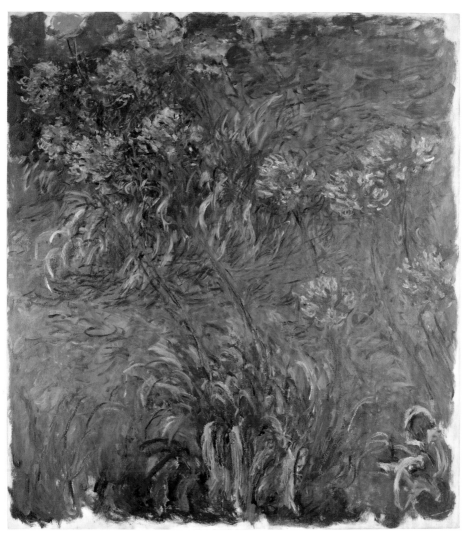

fig. 29
CLAUDE MONET
Agapanthus, 1914–26
Oil on canvas, 6' 6" x 70 1/4" (198.2 x 178.4 cm)
The Museum of Modern Art, New York
Gift of Sylvia Slifka in memory of Joseph Slifka

from which he would develop the *grandes décorations*; the plants, the trees, and the reflections were his sources of inspiration. Works such as *Agapanthus*, 1914–26 (fig. 29; given to the Museum in 1992), vividly portray the lily plants along the banks of the pond. Such a practice is far removed from the mentality of the Abstract Expressionists, who in their various ways all felt that everything they put on the canvas came from deep within themselves, as an emanation of the artist's psyche. Pollock summed it up concisely when Hans Hoffman asked him about the role of nature in his work: "I am nature," he snapped.[36]

The next generation was different. American painting was beginning to look more and more like Monet's late Water Lilies. While few of the older Abstract Expressionists had had the opportunity to go to Europe, younger artists were far more apt to travel. French painting again became a feasible model for artists such as Sam Francis and Joan Mitchell (see fig. 30), both of whom went to live in France full-time (Mitchell's property included a gardener's cottage that Monet had once occupied).[37] The extravagant lushness of the brushwork in paintings by Philip Guston suggested the comparison as well. The Museum of Modern Art acquired his painting *The Clock*, 1956–57 (fig. 31), at the same meeting at which it bought Monet's triptych. By the latter half of the 1950s, the term Abstract Impressionism was frequently invoked to describe the successor to Abstract Expressionism.

•••

In the spring of 1960 the events of the last decade found their culmination at The Museum of Modern Art in *Claude Monet: Seasons and Moments*. The exhibition, which presented landscape paintings from the 1860s onward, was organized by Princeton art historian and adjunct curator William C. Seitz, who had gone to France in the late 1950s to visit the places that Monet had painted. Seitz's photographs of these

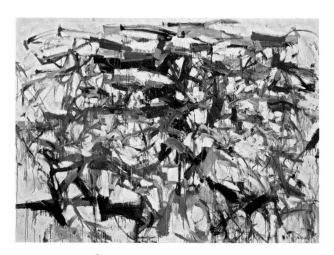

fig. 30
JOAN MITCHELL
Ladybug, 1957
Oil on canvas, 6' 5 $^7/_8$" x 9' (191.9 x 274 cm)
The Museum of Modern Art, New York
Purchase

fig. 31
PHILIP GUSTON
The Clock, 1956–57
Oil on canvas, 6' 4" x 64 $^1/_8$" (193.1 x 163 cm)
The Museum of Modern Art, New York
Gift of Mrs. Bliss Parkinson

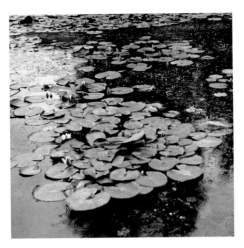

fig. 32
Photograph by William C. Seitz of
Monet's water lily pond, Giverny, 1957–58

sites, shot from vantage points as close as possible to those chosen
by the artist, were displayed in the exhibition to illuminate the close
relation between site and painting (see fig. 32). It would seem that this
approach—positioning Monet as a recorder of visible reality—might
disprove the argument that he anticipated mid-century abstraction.
But Seitz was able to make his method a paradoxical reinforcement
for that viewpoint, proposing that the paintings' abstraction is all the
more wondrous precisely because of their photographic veracity: "It is
surprising how little 'aesthetic distance' separates these images from
photographic actuality; yet in their isolation from other things, and
because of the mood they elicit, they seem, like pure thought or medita-
tion, abstract."[38]

As John Canaday recognized in his review of the exhibition
in the *New York Times*, "The intention of the exhibition at the Museum
of Modern Art . . . is to confirm Monet's new position as a painter of
the twentieth century rather than an anachronism." He went on to
astutely identify the misreading that had taken place over the prior
decade, arguing that "this painter who was concerned with neither
abstraction nor symbolism now appears as the precursor of a school of

contemporary art that has rejected the visible world."[39] The popularity
of the exhibition exceeded all expectations, and the attendance levels
were such that the Museum added evening hours.[40] Soon thereafter,
Michel Monet completed a three-year restoration project in Giverny,
aiming to return his father's water garden to its former glory.[41]

By this time, however, New York was host to the next wave of
art, one that would replace the abstract painting into whose service
Monet had been pressed. As Neo-Dada and Pop took hold in the gal-
leries, Abstract Expressionism suddenly became old-fashioned. Andy
Warhol later remembered the Monet exhibition at the Museum for
having been the death knell of the movement: "Don't you remember
the Monet retrospective at The Museum of Modern Art and what *that*
did to Abstract Expressionism? The galleries had been full of Abstract
Expressionists and Impressionists. And then, it was as if somebody
said, 'Why, look at Monet, that sweet old man, he was doing all these
wild things before you were born.'"[42] A young artist was better off pur-
suing subject matter in the supermarket or in the tabloids.

Nonetheless, Monet's late paintings were now an inevitable
reference point for contemporary artists. Pop's cultural climate may
be the furthest thing from the gardens at Giverny, but Monet comes to
mind when one thinks of how in 1964 Warhol himself would fill the Leo
Castelli Gallery in New York (and then the Sonnabend Gallery in Paris)
with dozens of Flower paintings made in several sizes and colors (see
fig. 33). James Rosenquist followed Monet's example when he installed
the panoramic *F-111* in the Castelli Gallery in 1965, wrapping the panels
around four walls to immerse the viewer in its imagery (fig. 34).[43]

In the decades since, the Water Lilies have remained touch-
stones, and countless artists have entered into dialogue with Monet
in unexpected ways. It is the mark of great art that it encourages such
re-readings, that its potential is far richer than the artist's conscious

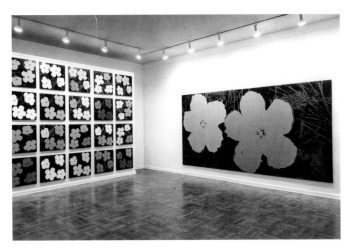

fig. 33
Installation view of *Andy Warhol: Flower Paintings*
at Leo Castelli Gallery, New York, 1964

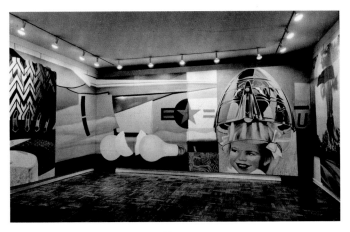

fig. 34
Installation view of *James Rosenquist: F-111*
at Leo Castelli Gallery, New York, 1965

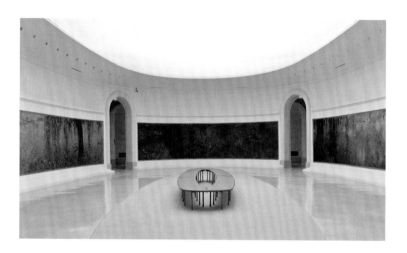

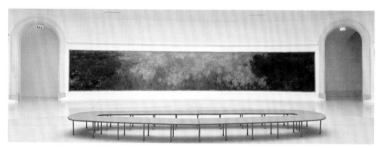

figs. 35 and 36
Installation views of Water Lilies
at the Musée de l'Orangerie, Paris,
after renovations completed in 2006

intentions or efforts could ever have defined. And it is the responsibility of the museum to make this work available for all that will be born of it in the future. But the artist's intentions stay relevant as well. Monet knew the pleasure that his art and his garden gave him, and he wished to extend it to coming generations. He wanted to provide a respite from an increasingly urban, commercial, and technological world. Nearly one hundred years later that world is exponentially more so, and viewers in the midst of the city continue to venerate Monet's evocation of nature's beauty (see figs. 35 and 36). Whereas a museum is a place that charts history, and with it time, it is also a place to pretend that time stands still, or at least moves as slowly as a cloud passing over a shimmering pond.

NOTES

The authors thank Paul Hayes Tucker for his generous advice and critical reading of this text.

1. See Ezra Pound, *Make It New* (London: Faber and Faber, 1934).
2. For an extensive discussion of this history, see Michael Leja, "The Monet Revival and New York School Abstraction," in *Monet in the 20th Century*, ed. Paul Hayes Tucker (New Haven: Yale University Press, 1998), 98–108.
3. On the Water Lilies' early years at the Orangerie, see Romy Golan, "Oceanic Sensations: Monet's *Grandes Décorations* and Mural Painting in France from 1927 to 1952," in *Monet in the 20th Century*, 86–97.
4. Ann Temkin telephone interview with Jack Youngerman, March 2009.
5. André Masson, "Monet le fondateur," *Verve* 7, no. 27–28 (1952): 68.
6. René Wehrli, *Claude Monet* (Zurich: Kunsthaus Zurich, 1952), 6.
7. Barnett Newman to William A. M. Burden, July 3, 1953 (copy), Museum Collection Files, Department of Painting and Sculpture, The Museum of Modern Art, New York. (All subsequently cited correspondence is from these files unless otherwise noted.) Reprinted as "Open Letter to William A. M. Burden, President of the Museum of Modern Art," in *Barnett Newman: Selected Writings and Interviews*, ed. John P. O'Neill (New York: Alfred A. Knopf, 1990), 38–40.
8. Alfred H. Barr, Jr. to William H. Jaffe, February 6, 1952.
9. Alfred H. Barr, Jr. to James Thrall Soby, April 13, 1955.
10. James Thrall Soby to Alfred H. Barr, Jr., April 17, 1955.
11. Alfred H. Barr, Jr. to James Thrall Soby, April 18, 1955.
12. Quoted in Lynn Zelevansky, "Dorothy Miller's 'Americans,' 1942–63," in *The Museum of Modern Art at Mid-Century: At Home and Abroad. Studies in Modern Art* 4 (1995): 74–75. Original in Dorothy Canning Miller Oral History, Archives of American Art, Smithsonian Institution, Washington, D.C., transcript of interviews conducted by Paul Cummings, May 26, 1970–September 28, 1971.
13. Alfred H. Barr, Jr. to Michel Monet, April 26, 1955.
14. Vasily Kandinsky, "Rückblicke," in *Kandinsky, 1901–1913* (Berlin: Verlag Der Sturm, 1913). Reprinted in English as "Reminiscences," in *Kandinsky: Complete Writings on Art*, vol. 1, eds. Kenneth C. Lindsay and Peter Vergo (Boston: G. K. Hall & Co., 1982), 363.
15. Press release dated November 30, 1955.
16. Michel Monet to John Rewald, November 14, 1955. Translation from French by the authors.
17. S.P., "About Art and Artists," *New York Times*, November 30, 1955.
18. A. L. Chanin, "Art," *The Nation*, December 24, 1955, 563.
19. Alfred H. Barr, Jr. to Mrs. Simon Guggenheim, February 9, 1956.

20. Daniel Wildenstein, *Monet: Or the Triumph of Impressionism*, catalogue raisonné in four volumes, vol. IV (Cologne: Benedikt Taschen Verlag, 1996), 1,030.

21. Alfred H. Barr, Jr., "Painting and Sculpture Collections, July 1, 1955 to December 31, 1956," *The Bulletin of The Museum of Modern Art* 24, no. 4 (Summer 1957): 3.

22. Alexander Liberman, "Monet," *Vogue* 126 (July 1955): 64–69, 106.

23. Leo Steinberg, "Month in Review," *Arts* 30, no. 5 (February 1956): 46–48. Reprinted as "Monet's Water Lilies," in Steinberg, *Other Criteria: Confrontations with Twentieth-Century Art* (New York: Oxford University Press, 1972), 235–39.

24. Thomas B. Hess, "Monet: Tithonus at Giverny," *Art News* 55, no. 6 (October 1956): 42, 53.

25. Clement Greenberg, "The Later Monet," *Art News Annual* 26 (1957): 132–48, 194–96, quote p. 196. Reprinted in John O'Brian, ed., *Clement Greenberg, The Collected Essays and Criticism*, vol. 4 (Chicago: The University of Chicago Press, 1986–1993), 3–11.

26. E. C. Goossen, "The Big Canvas," *Art International* 2, no. 8 (November 1958): 45–47, quote p. 46. Reprinted in Geoffrey Battcock, ed., *The New Art* (New York: E. P. Dutton & Co., 1973), 57–65.

27. David Sylvester, "London Ponders Monet as a Modernist," *New York Times*, October 6, 1957. Reprinted in Sylvester, *About Modern Art* (New Haven: Yale University Press, 2002), 74–76.

28. Sanka Knox, "Violations Listed in Fire at Museum," *New York Times*, April 17, 1958.

29. "Talk of the Town," *The New Yorker*, April 26, 1958, 24.

30. The Museum donated the smaller painting's remains to the New York University Conservation Clinic, which was under the direction of Sheldon Keck. With his wife, Caroline, Keck was a frequent conservation consultant for the Museum. This material is now located at NYU's Institute of Fine Arts.

31. Daniel N. Flavin to Alfred H. Barr, Jr., April 16, 1958, Alfred H. Barr, Jr. Papers [I.303], The Museum of Modern Art Archives, New York.

32. Alfred H. Barr, Jr. to Dorothy Miller, April 15, 1958.

33. Sarah Rubenstein, comptroller, to Betsy Jones, secretary of collections, September 9, 1960.

34. Alfred H. Barr, Jr. to Mrs. Simon Guggenheim, December 22, 1958.

35. Authors' telephone interviews with Ellsworth Kelly, Jack Youngerman, and Fred Pajerski, nephew of Fred Mitchell, March and May 2009.

36. Jackson Pollock as quoted by Lee Krasner in oral history interview with Krasner, November 2, 1964–April 11, 1968, Archives of American Art, Smithsonian Institution.

37. Klaus Kertess, *Joan Mitchell* (New York: Harry N. Abrams, Inc., 1997), 181–82.

38. William C. Seitz, *Claude Monet: Seasons and Moments* (New York: The Museum of Modern Art, 1960), 43.

39. John Canaday, "Art: Monet Exhibition. Comprehensive Landscape Show Opens Today at the Modern Museum," *New York Times*, March 9, 1960.

40. Letter to lenders sent by Monroe Wheeler, Director of Exhibitions and Publications, The Museum of Modern Art, and Richard F. Brown, Chief Curator of Art, Los Angeles County Museum of Art, August 30, 1960. Curatorial Exhibition Files [Exh. #660], The Museum of Modern Art Archives, New York. Many thanks to Michelle Harvey, Associate Archivist, for her generosity in sharing this information.

41. IZIS and Jean Saucet, "Claude Monet: le jardin des chefs-d'oeuvre," *Paris MATCH*, no. 606 (November 19, 1960): 72–85.

42. Andy Warhol, "Warhol Interviews Bourdon," 1962–63, previously unpublished; in Kenneth Goldsmith, ed., *I'll Be Your Mirror: The Selected Andy Warhol Interviews* (New York: Carroll & Graf Publishers, 2004), 14.

43. Ann Temkin, interview with James Rosenquist, March 2009. Rosenquist invoked Monet while discussing the role of peripheral vision in painting: "Monet stood in a circle of his own paintings so that he could only see his own colors." "*F-111*," undated artist statement, Museum Collection Files, Department of Painting and Sculpture, The Museum of Modern Art, New York. *F-111* is now in the collection of The Museum of Modern Art.

SELECTED BIBLIOGRAPHY

Georgel, Pierre. *Claude Monet: Nymphéas.* Paris: Hazan, 1999.

Hoog, Michel. *Musée de l'Orangerie: The Nymphéas of Claude Monet.* Paris: Editions de la Réunion des musées nationaux, 2006.

Moffett, Charles S. *Monet's Water Lilies.* New York: The Metropolitan Museum of Art, 1978.

Moffett, Charles S., and James N. Wood. *Monet's Years at Giverny: Beyond Impressionism.* New York: The Metropolitan Museum of Art, 1978.

Rey, Jean Dominique, and Denis Rouart. *Monet Water Lilies: The Complete Series.* Catalogue raisonné simultaneously published in French as *Monet: Les Nymphéas.* Paris: Flammarion, 2008.

Seitz, William C. *Claude Monet: Seasons and Moments.* New York: The Museum of Modern Art, 1960.

Spate, Virginia. *Claude Monet: Life and Work.* New York: Rizzoli, 1992.

Stuckey, Charles F. *Monet Water Lilies.* New York: Hugh Lauter Levin Associates, 1988.

—————. *Claude Monet, 1840–1926.* Chicago: The Art Institute of Chicago; New York: Thames & Hudson, Inc., 1995.

Tucker, Paul Hayes. *Monet in the 20th Century.* New Haven: Yale University Press, 1998. With essays by John House, Romy Golan, and Michael Leja.

—————. *Claude Monet: Life and Art.* New Haven: Yale University Press, 1995.

Wildenstein, Daniel. *Monet: Or the Triumph of Impressionism.* Catalogue raisonné in four volumes. Cologne: Benedikt Taschen Verlag, 1996.

Published in conjunction with the exhibition *Monet's Water Lilies*, organized by Ann Temkin, The Marie-Josée and Henry Kravis Chief Curator of Painting and Sculpture, at The Museum of Modern Art, New York, September 13, 2009– spring 2010

The exhibition is made possible by
Ⓗ **HANJIN SHIPPING**

Produced by the Department of Publications, The Museum of Modern Art, New York

Edited by Jennifer Liese
Designed by Amanda Washburn
Production by Christina Grillo
Printed and bound by Oceanic Graphic Printing, Inc., China
This book is typeset in Dolly
The paper is 140 gsm Golden East Matte Artpaper

Published by The Museum of Modern Art
11 West 53rd Street
New York, New York 10019-5497
www.moma.org

Library of Congress Control Number: 2009929588
ISBN: 978-0-87070-774-2

Distributed in the United States and Canada by D.A.P./Distributed Art Publishers, Inc., 155 Sixth Avenue, 2nd floor, New York, New York 10013
www.artbooks.com

Distributed outside the United States and Canada by Thames & Hudson Ltd, 181 High Holborn, London WC1V 7QX
www.thamesandhudson.com

Front and back cover:
Claude Monet
Water Lilies (detail), 1914–26
Oil on canvas, three panels, each 6' 6 ³/₄" x 13' 11 ¹/₄" (200 x 424.8 cm); overall 6' 6 ³/₄" x 41' 10 ³/₈" (200 x 1,276 cm)
The Museum of Modern Art, New York. Mrs. Simon Guggenheim Fund

Inside cover flaps:
Claude Monet in his studio, 1922

Frontispiece:
Claude Monet in his garden, n. d.

Printed in China